Dante's Gallery of Rogues

PAINTINGS OF DANTE'S *INFERNO* BY VINCENZO R. LATELLA

EDITED, WITH AN INTRODUCTORY ESSAY BY ANNE PAOLUCCI

COPYRIGHT © 2001 BY COUNCIL ON NATIONAL LITERATURES
ISBN: 0-918680-94-8

Library of Congress Cataloging-in-Publication Data

Latella, Vincenzo R.
 Dante's gallery of rogues : thirty-six color reproductions of original paintings
illustrating Dante's Inferno / by Vincenzo R. Latella ; with an introductory essay
by Anne Paolucci.
 p. cm.
 Prepared in conjunction with an exhibit of original paintings, held at the
CNL/Anne and Henry Paolucci International Conference Center in Middle
Village, New York, March 23, 2001.
 ISBN 0-918680-94-8
 1. Latella, Vincenzo R.–Exhibitions. 2. Dante Alighieri, 1265-1321.
Inferno–Illustrations–Exhibitions. 3. Hell in art–Exhibitions. I. Paolucci, Anne.
II. Anne and Henry Paolucci International Conference Center. III. Title.

 PQ4329 L38 2001
 759.13–dc21 2001028127

Published by
COUNCIL ON NATIONAL LITERATURES

CNL/ANNE AND HENRY PAOLUCCI INTERNATIONAL CONFERENCE CENTER
68-02 METROPOLITAN AVENUE
MIDDLE VILLAGE, NEW YORK 11379

CONTENTS

ACKNOWLEDGEMENTS 5

BRIEF CHRONOLOGY 7

"THE STRIDENT VOICES OF HELL" (ANNE PAOLUCCI) 11

 I. Telling the Story 11

 II. The Three Canticles 13

 III. The Political Thesis 15

 IV. The Realm of Satan 21

 General Comments 21

 The Circles of Hell 21

 The Topography or Moral Geography of Hell 22

 Satan 23

 The Arch-Traitors: Brutus, Cassius, and Judas 24

 The Augustinian View 25

 The Beginning: Unanswered Questions 29

 V. Some Observations on Dante in America and Three Major British Poets Influenced by Dante 36

 Notes 38

REPRODUCTIONS 41

 PORTRAIT OF DANTE 43

 CANTO I, 1-3 44, 45

 CANTO II, 139-142 46, 47

 CANTO III, 7-9 48, 49

 CANTO IV, 7-9 50, 51

 CANTO V, 103-105 52, 53

 CANTO VI, 52-54 54, 55

 CANTO VII, 109-111 56, 57

 CANTO VIII, 28-30 58, 59

Canto IX, 88-90	60, 61
Canto X, 22-24	62, 63
Canto XI, 4-7	64, 65
Canto XII, 80-85	66, 67
Canto XIII, 124-126	68, 69
Canto XIV, 28-30	70, 71
Canto XV, 16-19	72, 73
Canto XVI, 130-132	74, 75
Canto XVII, 133-136	76, 77
Canto XVIII, 19-21	78, 79
Canto XIX, 22-24	80, 81
Canto XX, 13-15	82, 83
Canto XXI, 79-84	84, 85
Canto XXII, 127-129	86, 87
Canto XXIII, 1-3	88, 89
Canto XXIV, 103-105	90, 91
Canto XXV, 25-27	92, 93
Canto XXVI, 55-57	94, 95
Canto XXVII, 31-33	96, 97
Canto XXVIII, 124-126	98, 99
Canto XXIX, 1-3	100, 101
Canto XXX, 22-24	102, 103
Canto XXXI, 133-135	104, 105
Canto XXXII, 22-24	106, 107
Canto XXXIII, 1-3	108, 109
Canto XXXIV, 136-139	110, 111
BIOGRAPHICAL NOTE	115

ACKNOWLEDGEMENTS

The Council on National Literatures is pleased to have made possible the publication of this unique collection of color reproductions of original oil paintings of Dante's *Inferno* by Vincenzo Latella. Under a special arrangement with Griffon House Publications, and continuing a new initiative begun over a year ago, CNL will distribute *Dante's Gallery of Rogues,* as a gift item, to over 700 libraries both here and abroad.

I am proud to have been able to work on this project with Faustino Quintanilla, Director and Curator of the Art Gallery of Queensborough Community College/CUNY. We exchanged many ideas and suggestions as the book took shape, and I am grateful for his generous help. Thanks are due also to his staff, especially Ardelle Donohue, production assistant, who helped design the book.

The originals of the paintings reproduced in *Dante's Gallery of Rogues* were featured in an exhibit held on March 23, 2001, at the CNL Anne and Henry Paolucci International Conference Center, in New York. The exhibit, prepared in collaboration with Faustino Quintanilla and the Art Gallery of Queensborough Community College of CUNY, provided the general public, especially area students and teachers, with an unusual opportunity to admire Vincenzo R. Latella's series on Dante. We wish to thank all those who helped in preparing the exhibit — Bob Lambert and his crew, Rosemarie De Siervi, Mimi Valenti and her efficient staff, and, once again, Faustino Quintanilla, who supervised every detail of the preparations. I must also commend the CNL Board of Directors and the Board of Directors of The Bagehot Council, who supported this project in every way.

It is only fitting that an exhibit featuring the greatest poet of all time should draw the interest and support of not only the Art Gallery of Queensborough Community College of CUNY but also The American Italian Cultural Roundtable, a group dedicated to promoting the best of Italian culture. On behalf of the CNL Board, I extend to both organizations a very special thanks for co-

hosting the event. The public's response assured us that the time and energy given to its planning, and to the publication of *Dante's Gallery of Rogues,* was well worth the trouble.

This project marks the beginning of the second year of activities at the CNL/ANNE AND HENRY PAOLUCCI INTERNATIONAL CONFERENCE CENTER. All of us connected with the Center look forward, in the months ahead, to many more interesting programs that will enhance multiethnic awareness and promote literary studies within an expanded multicomparative spectrum.

NOTE ON THE TEXT.

Italian excerpts accompanying the reproductions are from *La Divina Commedia di Dante Alighieri, Volume Primo, Inferno,* edited with commentary by Luigi Pietrobono, 4th edition, Società Editrice Internazionale di Torino (1966). The English translations are my own.

NOTE ON THE PAINTINGS.

The original works reproduced in this book were painted between 1978 and 1980. All were done in oil on canvas, and all measure 24" x 30".

A.P.

BRIEF CHRONOLOGY

1265 (May)	Dante is born in Florence.
1265	Manfred is defeated and killed by Charles of Anjou.
1268	Conradin, the last of the German Imperial Hohenstaufens, is put to death by Charles of Anjou, who becomes King of Naples.
1274	Dante first sees Beatrice, daughter of Folco Portinari.
1276	Dante's precursor in "the sweet new style" ("dolce stil nuovo"), the poet Guido Guinicelli, dies. The painter Giotto is born.
1290	Beatrice dies.
1291	Dante marries Gemma de' Donati.
1294	Celestine V abdicates the Papal throne. Dante writes his *Vita Nuova*.
1300	Dante has his Vision. The painter Cimabue (Giotto's teacher) dies. Dante's close friend, the poet Guido Cavalcanti, dies.
1302	During a trip to Rome, Dante is fined 8000 lire and banished for two years (January 27). Later he is sentenced to be burned alive, if taken (March 10).
1303	Pope Boniface VIII dies.
1306	Dante visits Padua.
1308	Dante seeks asylum at Verona, with the della Scala family. He continues his wanderings over various parts of Italy.
1309	Charles II, King of Naples, dies.
1313	The Emperor Henry of Luxemburgh, by whom Dante had hoped to be restored to Florence, dies.
1314	Philip IV of France dies.
1321 (July)	Dante dies in Ravenna and is buried there.

Dante's Gallery of Rogues

THE STRIDENT VOICES OF HELL*

"Lasciate ogni speranza voi ch'entrate."
INFERNO. III, 9

"The undiscovered country from whose bourn
No traveler returns"
HAMLET. III, 1, 79-80

"I reached the portal common spirits fear,
And read the words above it, dark and clear,
'Leave hope behind, all ye who enter here'."
JAMES THOMSON, *THE CITY
OF DREADFUL NIGHT*

I. TELLING THE STORY

The well-known mystery writer and enthusiastic critic-translator of *The Divine Comedy,* Dorothy L. Sayers, calls Dante's poem "a story of adventure."[1] It has, she keeps reminding us, all the elements we associate with good narrative: "structure, speed, particularity, style," and "a universe of breathing characters."[2] And, fueling the narrative, a great poetic imagination as well.

Dante had learned a great deal about telling a story from his master Virgil, and from others like Ovid and Statius; he knew the Vulgate "inside out;" and he had most certainly profited from his close and appreciative reading of the romance writers of the northern tradition.

All this, Sayers tells us, contributed to making Dante "a miraculous story-teller."[3] He seems fully aware that in telling a story he — the sophisticated poet of the *Vita Nuova* and *Convivio*, of courtly love — has humbled himself, catering to a more general audience. In fact, he had already decided to write his great poem in Italian, the "vulgar" tongue, rather than in Latin — something unheard of, at the time, for a poem or any

work dealing with high philosophy, religion, morality, and metaphysics.

Why indeed did a poet so superbly trained, with such experience and skill in such a variety of poetic forms, fully aware that serious works were still written in Latin, that the "vulgar" was used only for the more common exchanges and for simple love lyrics — why did he deliberately choose to write the *Commedia* in Italian? No answer can satisfy completely except his own, and that one is not altogether clear. We know he had carefully studied the sixteen major tongues of Italy, examining each in detail, aiming to find the best qualities of each so that they might be combined into one tongue that could perhaps serve the entire peninsula (*De Vulgari Eloquentia*). Whatever his theory, he tested it in the *Commedia*. There the Italian language was shaped and molded to fit the poet's needs. In Dante's hands, it responded with unexpected fluidity, power, and grace. It proved it could indeed tackle that astonishing mix of history, philosophy, politics, preaching, satire, romance, autobiography, and adventure — and in a manner that suggests that the language had been used that way for decades. Actually, Dante was the first to do so.

His "colossal humility" as a story-teller is offset by a "colossal self-confidence"[4] in his overall abilities as a poet. He does not hesitate to admit his own greatness and vote himself into the eternal hall of fame. But then, anything less would have been less than true.

"The structure of the thing is in every way astonishing,"[5] Sayers notes; "the sheer pace is in fact, extraordinary."[6] Although he never forgets that other magic element, which places him apart from so many other excellent story-tellers, Dante "does not assume his singing robes; he merely assumes that he has them on The poem does not start off like an epic, but with the disarming simplicity of a ballad or a romance or a fairy-tale."[7] This is a significant observation and we will

have occasion to see just how extraordinary the beginning of the poem is.

II. THE THREE CANTICLES

Dante tells us that his epic poem is a "comedy." He wasn't suggesting the poem was funny, although there is humor in it; what he meant was that the work has a "fortunate" outcome, it ends well. Later commentators added the word "divine," no doubt to express their appreciation of the poem's beauty, but also, perhaps, as a reminder of the journey's goal, the reward awaiting the sinner who confesses his error: salvation. Dante himself refers to the work as "poema sacro" by the time he reaches *Paradiso*.

The journey described is in three parts. The multifaceted display of the self-serving will is the subject matter of the *Inferno*. In this first canticle, Dante reviews the ways in which human beings destroy their God-given faculties by indulging their appetites and perverting their judgment. The sinners in Hell have put themselves first in all things. They are forever shut out from the light and love of God. Their vision has not altered, their passions have not diminished. If anything, they are even more assertive, more demanding in their willfulness. At the same time, they see clearly the full implications of their actions, the completed deed, as it were.

The second part of the journey, *Purgatorio,* is about self-effacement and rehabilitation. In it we witness the purification of the will, which has come to recognize the error of its ways and its innate love for the Good. *Purgatorio* prepares the soul for the return to God. Here the penitents are not the assertive "personalities" of Hell; they are unobtrusive participants in a therapeutic program meant to refine their sensibilities and hone their talents. For *Purgatorio* is a great hymn to the fine arts, peopled with musicians, poets, artists,

as they express the beauty and goodness of God. The poet seduces us with the best in art, then moves beyond art to reconstituted nature, nature restored to its pristine beauty at the very top of the Mountain of *Purgatorio*. All that, he reminds us, will disappear on the day of judgment, when *Purgatorio* and everything in it, all the arts and the new Eden, will be absorbed into Paradise.

In the final cantos of *Purgatorio,* the reconstituted will, purified through a new Baptism, Confession, and Absolution; strengthened by the allegorical pageant depicting the history of Christianity and Holy Church, from the beginning right up to Dante's time; having witnessed the destructive confrontation between universal Church and universal Empire, is now prepared to enter the glorious, *eternal present* of *Paradiso.*

This third canticle educates us emotionally and in every other way for the sight of the Holy Trinity and God. But Dante warns us more than once that our spiritual eyes must be made strong to withstand the vision of the Godhead. To make his point, he introduces us, along the way, to the saints, theologians, and martyrs, whose manifest love for God shines in and through them. Not surprisingly, the *Paradiso* is also a refresher course in theology, dogma, and the mysteries of Faith, even *explication de texte,* as in the beautiful rendering of the "Hail Mary" by St. Bernard, in whose care Beatrice has left Dante. It is St. Bernard, the devoted advocate of Mary, who now intercedes for Dante; and it is Mary who serves as the final intermediary between Dante and the vision of the triune God.

Paradiso is an ever-more challenging theological and spiritual illumination. There is no vestige here of worldly beauty, history, art, or reconstituted nature. Everything has been transformed. Dante alerts us to the difficulty of describing this phase of the journey by using a wealth of similes and

other images that suggest what is in final analysis an experience beyond the senses, beyond the grasp of our merely human faculties.

III. THE POLITICAL THESIS

One large reason for the astounding response Dante continues to elicit through the centuries, from the time of Boccaccio (the first to take on the poem in a series of lectures in Florence), down to our own day, is that the struggle Dante described continues in one form or another, its power undiminished. His message about social chaos and personal damnation, and the connection between the two, carries down to our own age.

Dante wrote his epic poem during his political exile, which began in 1302 and lasted until his death in Ravenna in 1321. He was driven from Florence by petty power-politics. Accused of barratry, he refused to pay the fine imposed on him, knowing himself to be innocent of the charge, and chose not to recognize the ruling of the Court. His refusal to submit to the sentence and to recognize the duly constituted authority that had passed judgment on him, forced his peers to sentence him to permanent exile with the threat of death should he ever set foot in his native city again.

Against Dante's own personal political difficulties is the large power struggle which is the burden of the poem: the destructive confrontation between the supporters of imperial rule and those of the Pope, a struggle which fuels Dante's treatise, *De Monarchia (On World Government),* and which we hear in a variety of poetic refrains throughout the *Commedia.*

For Dante the need for separate and distinct temporal and spiritual leadership in the world is essential and basic. The *Commedia* is built on this assumption. It weaves its way

in and out of the poem in recurring motifs. The matter is barely touched on in the opening canto, but Dante's encounters with Farinata, Ugolino and others in *Inferno* and elsewhere are variations of that theme, creating a cumulative and powerful effect. At the very center of the earth, where Satan has been thrust from the heavens, the theme reaches one of its most memorable expressions.

The most explicit expression of that theme, and an excellent illustration of Dante's command of the architectural structure which enables him to minimize explanations and descriptions, is Canto XVI of *Purgatorio,* where the wrathful are being punished. It is up to us to discover that this is precisely the midpoint of the poem, the fiftieth of 100 cantos. What this tells us is that the canto is centrally located and therefore of central importance. (Once we understand how Dante works these techniques, we begin to look for more, and we are rarely disappointed.)

The canto deals, in fact, with the political question, in its fullest historical and philosophical context. Virgil has asked Dante to inquire if they are indeed going in the right direction (unlike similar encounters in *Inferno,* no one here will try to mislead them). Dante accordingly addresses one of the penitents. The man who responds tells him, in four tight lines, that his name is Marc, that he is from Lombardy, where he followed virtue and goodness, that he made every effort to uphold those values that everyone is now bent on destroying, and, yes, they're on the right track.

But Marc's mention of virtue and values has made Dante forget his usual modesty, and uncharacteristically he blurts out another question that is bothering him: "Tell me, why has the world lost those values you and others hold dear? Tell me, so I can report back to the others left behind, because some people insist the cause of evil and disorder is to be found in the influence of the stars, others that it's here

among us, our doing." Marc sighs, but answers. And that answer has become one of the high points of the poem, for in addition to anticipating the guileless Wordsworthian soul seeking its Maker from the moment of its birth, in addition to a magnificent poetic account of the Platonic ladder of love, it also gives us an unforgettable political thesis on the need to separate temporal and spiritual authority, if mankind is to find its way back to God. It is an important moral and political landmark in the *Commedia* but also contains one of the most beautiful pieces of sheer poetry every written.

Marc Lombard first answers Dante's question about free will. Even to ask the question shows how blind men have become, he tells Dante bluntly. Down there you all think that things happen of necessity. If that were the case, you would have no choices, there would be no reason to rejoice in the good and avoid evil. At first, it's hard, he says; but you have in you the power to seek freedom and better things.

> "[T]he world is blind;
> And you must come from there.
> You, the living, trace all causes
> To the stars, as though they draw
> Things after them by necessity.
> If this were so, free will would be destroyed in you
> And there would be no just reason for rejoicing
> In goodness and grieving over evil.
> The stars first spur you into action —
> I don't say all action, but even if I did,
> You have a light that shows you good from bad,
> And free will, which if it stands firm
> Through the first battles with the stars,
> Will win out in the end, if nourished properly.
> Free will leads to a greater force a better nature
> And creates in you the mind over which
> The stars have no control.
> Therefore, if the world has gone astray,
> The cause is in yourselves, in you the question lies,

As I will now truthfully reveal to you."

"Lo mondo è cieco, e tu vien ben da lui.
Voi che vivete ogni cagion recate
 Per suso al cielo, pur come se tutto
 Movesse seco di necessitate.
Se così fosse, in voi fora distrutto
 Libero arbitrio, e non fora giustizia,
 Per ben letizia, e per male aver lutto.
Lo ciel i vostri movimenti inizia, —
 Non dico tutti, ma posto ch' i' 'l dica,
 Lume v' è dato a bene e a malizia,
E libero voler, che, se fatica
 Ne le prime battaglie col ciel dura,
 Poi vince tutto, se ben si notrica.
A maggior forza e a miglior natura
 Liberi soggiacete, e quella cria
 La mente in voi, che 'l ciel non ha in sua cura.
Però, se 'l mondo presente disvia,
 In voi è la cagione, in voi si cheggia
 Ed io te ne sarò or vera spia."

Having assured Dante that our free will, not the stars or the influences of nature, is the final arbiter in all choices, Marc Lombard gives this beautiful account of the newly-created soul seeking the things that give it joy, in its unconscious and natural effort to return to the source of its happiness:

"From his hand, who delights in her
Even before she comes into being,
The simple new-born soul, like a young maid
Plays, weeping and laughing, knowing
Nothing except that, moved by her happy maker,
She willingly returns to that which gives her joy.
First, she finds pleasure in a tiny good;
Misled, she rushes after it,
Unless someone or some restraint
Wrench her from that love."

"Esce di mano a lui che la vagheggia
 Prima she sia, — a guisa di fanciulla
 Che piangendo e ridendo pargoleggia, —
L'anima semplicetta, che sa nulla,
 Salvo che, mossa da lieto fattore,
 Volentier torna a ciò che la trastulla.
Di picciol bene in pria sente sapore;
 Quivi s' inganna, e dietro ad esso corre,
 Se guida o fren non torce son amore."

To guide the unsuspecting naive soul in its first automatic response toward the things that give it joy, some measure of control must be applied. At this point Marc Lombard introduces the major theme:

"Therefore laws had to be found to act as brakes,
A king had to be found who could discern at least
The towers of the true city.
We have the laws, but who enforces them?
No one; for the shepherd who leads the way
Can meditate but lacks the cloven hoof.[8]
And those who follow, seeing their leader
Reach for those goods they themselves desire,
Settle for them and ask for nothing more.
You can well see that evil leadership
Is the cause of the world's ills
Not nature corrupted in you.
Rome, that made the good world,
Once had two suns, lighting one and another road,
That of the world and that of God.
One has put out the other;
And the sword is joined with the crozier;
Together they can only do damage
Because thus joined one does not fear the other.
If you don't believe me, think of an ear of corn,
How every fruit is known by its seed." [9]

"Onde convenne legge per fren porre;
 Convenne rege aver, che discernesse
 De la vera città almen la torre.
Le leggi son, ma chi pon mano ad esse?
 Nullo; però che 'l pastor che procede
 Rugumar può, ma non ha l' unghie fesse.
Per che la gente, che sua guida vede
 Pur a quel ben fedire ond' ella è ghiotta,
 Di quel si pasce, e più oltre non chiede.
Ben puoi veder che la mala condotta
 È la cagion che 'l mondo ha fatto reo,
 E non natura che 'n voi sia corrotta.
Soleva Roma, che 'l buon mondo feo,
 Due soli aver, che 'l una e l' altra strada
 Facean veder, e del mondo e di Deo.
L' un l' altro ha spento, ed è giunta la spada
 Col pastorale; e l' un con l' altro insieme
 Per viva forza mal convien che vada,
Però che giunti, l 'un l' altro non teme.
 Se non mi credi, pon mente alla spiga,
 Ch' ogn' erba si conosce per lo seme."[10]

There's more before the canto comes to an end, but these passages should suffice. Dante makes very clear that the world has gone astray because the papal crozier and the imperial sword have come together, thereby destroying the delicate balance of the two sources of power, temporal and spiritual, without which man cannot hope to find salvation. This will be the major theme of the *Inferno* and the burden of the entire poem.

Three centuries later, in a similar situation, another Florentine, Niccolo Macchiavelli, will take on many of the same arguments to produce a powerful practical manifesto on *realpolitik*: *The Prince*.

IV. THE REALM OF SATAN

General Comments

Inferno is the most dramatic and richest reflection of this political, social, and religious chaos. It is also the place where the most assertive political voices are heard justifying their partisan attitudes. The sinners have lost their moral bearings because of their self-indulgence; and they are held responsible for their conduct because free will, God's great gift to mankind, has been turned toward self-gratification. But Dante never lets us forget that the Pope and the Emperor are also responsible for having betrayed their trust, their great office as leaders. They have failed in their given task to protect and guide mankind, each in his own way, according to God's grand design.

This and other themes are set within an architectural and topographical design that is itself a poetic statement. That design allows Dante tremendous economy with words, since the structure is itself a moral and spiritual statement.

In *Paradiso,* Dante sets his meetings and interviews against the familiar astronomical heavens, in order to dismiss in an impressive way the notion that the will is in any important way subject to the influence of the stars and planets. In *Purgatorio,* the ledges on the mountain represent the traditional sins and provide us with artistic examplars to soothe and encourage the soul in its journey of expiation. But in *Inferno,* where there is neither light nor stars nor recognizable landmarks to go by, the very structure must guide us. Dante must create an environment that needs no large explanation, that speaks for itself as we move further and deeper into it.

The Circles of Hell

Inferno is a huge cavity shaped like an inverted trun-

cated cone, widest at the top, narrowing to almost a point at the center of the earth, where Dante and Virgil will slowly move, to emerge into the open again, finally, to see the stars and the mountain of *Purgatorio*.

The entire cavernous area is divided into nine circles or ledges of different widths and characteristics, where sinners are relegated for all eternity with ingenious punishments created by Dante the poet to fit the sin both morally and poetically. The circles or ledges are separated from one another by cliffs of varying steepness and height. Two enormous precipices divide it roughly into three horizontal sections. A huge wall circling one of the terraces severs the outermost section from the other two, creating the regions of Upper and Lower Hell. The latter is referred to as The City of Dis.

In the upper part of Hell are those who sinned against nature. The sins of excesses are familiar and appear again and again in traditional literature and in church manuals: lust, gluttony, avarice and prodigality, anger, and (perhaps to mark the transition into the lower regions) the sin of heresy. At this point, the walls of Dis rise up to separate this first large area from the second narrower one, where the violent are punished. The descent into the area of the fraudulent is steep and difficult, every step a real danger and threat. Beyond this narrow area, or rather at the very center of it, stuck there, filling up what remains of the opening, is the beastly figure of Satan himself.

The Topography or Moral Geography of Hell

By setting up his place for the damned within an inverted truncated cone set in the middle of the earth, Dante is already speaking allegorically and morally. Utter darkness tells us, without any need for explanations, that this is a place where we can easily lose ourselves, since there are no

familiar guidelines or landmarks to follow. Darkness also denotes the absence of light; and in Dante's moral universe (as in that of Aeschylus, Milton, and so many others), light is synonymous with knowledge, illumination, insight. All these are missing where there is darkness. The very geography of the place tells us quickly that we are growing more and more restricted in our movements, in our ability to step from moment to moment, from ledge to ledge, without error, without danger. Finally, marking the dead-end or *cul-de-sac*, which is the very bottom of the pit, Lucifer corks up the narrow opening, all that remains of Hell.

The closing in of the walls as we go further down into the darkness of Hell, the increasing cold, the sounds and smells that assail us, the anger, rage and frustration of the inhabitants of the place, the visual images drained of all humanity, tell us in unambiguous language that Hell is where freedom and love have forever been lost.

Satan

"I did not die, I did not remain alive," Dante tells us[11] at the sight of Satan. He stresses how difficult it is to approximate that terrible sight, to find the proper words to describe it, but of course, in so doing he is giving us both the measure of the difficulty and the extent of his success. He succeeds primarily by using familiar symbolic allusions to highlight Satan's condition and that of the traitors who will be joined to him for all eternity. Dante's imagery at this point in the poem reinforces the notion of bestiality, of a new sub-human species created by the fall from grace. Satan is described in language that brings to mind the ugliest animals. He has three heads: the one in front is red; the one on the right is a yellowish white; the left one is black. Directly below these, two huge bat-like winds move slowly, creating the cold wind and ice of Cocytus.

In his powerfully evocative clusters of images Dante

quickly is able to impress upon us that Satan is a fallen super-being who, in his betrayal of God, was transformed into a sub-human being, something quite new and awful, one of a kind. He is not a mere animal, for animals are created by God to serve a good purpose. Neither is he simply *in*-human, for he was never human to begin with. Everything about him is unnatural, repulsive, disgusting, ugly, perverted. His very appearance is nothing we can relate to; it is an invention of Dante's. But we have no doubt as to what this caricature or monster represents. His frustrated tears, dripping from three pairs of eyes over three chins, coming together with gore and bloody foam drooling from each of three mouths, where he chomps at the sinners trapped in them, his clawing, which strips the skin off their backs again and again, his relentless biting, crushing their bodies between his teeth, torturing them in whatever way possible and within his power, is the only way Satan is able to give vent to his anger, his unrelieved frustration, his powerful rage. He is in himself the example *par excellence,* the confirmation if you will, of the impotence represented by Hell.

The Arch-Traitors: Brutus, Cassius, and Judas

All around that small opening, embedded in what seem like sheets of glass, are the worst of all sinners, those who have betrayed their lords and masters, who have destroyed the most intimate trust between human beings. They are visible through the icy surface like bits of straw, in all kinds of positions, some standing, some back to back, head to head, some bent, completely covered by the ice.

But it is the three sinners in Satan's grasp that draw Dante's special attention. Dante the Poet has put them there, and for a good reason; Dante the Narrator has to discover them there and make them part of the story he is telling. And by this time, we can recognize without too much explanation

both the terrible betrayal they have committed and the large consequences of that betrayal.

Hanging from the black muzzle, Virgil explains, is Brutus; hanging from the yellowish mouth is Cassius. The one in the middle mouth, whose head is hidden inside the moving red jaws and whose legs are dangling below, is Judas Iscariot. No great surprise, once we grasp that, for Dante, Brutus and Cassius are not the heroic defenders of the Roman Republic but the arch-traitors who killed Julius Caesar and tried to prevent the launching of the Roman Empire. That Empire came finally into being; and under the great Augustus Caesar, Virgil himself was born. As for Judas Iscariot, the betrayer of Christ and the Universal Church, Virgil does nothing more than identify him. No further explanations are necessary. The rest of the traitors in that hell hole are shown forever embedded in a cold and dark transparency, like insects trapped under a laminated surface. It is the ultimate humiliation, the most painful *reductio* of the human soul to agonizing awareness of its eternal fate.

The entire last scene is full of sounds and smells and sights that defy description. Neither Virgil nor Dante say much as they struggle to climb out of the pit of Hell. They must find their way along the ribs of Satan's bat-like wings, holding on for dear life. All kinds of dangers lurk around them and every step threatens to plummet them back into the dark pit. The moral and spiritual implications of this moment are clear enough but cannot be minimized. If Dante survives, it is only because, on another level of being, his future has been assured.

The Augustinian View

Coming for the first time to Dante's bestial Satan from the eloquent "Byronic hero" of Milton's *Paradise Lost*, T. S. Eliot was honest enough to note that many English read-

ers might take away from the last Canto of *Inferno* "the impression of a Devil suffering like the human damned souls," an impression that makes us keenly aware of the contrast between the two representations and forces upon us the conclusion that "the *kind* of suffering experienced by the Spirit of Evil," as described by Dante, "should be represented as utterly different."[12] Eliot, as one might expect, eventually comes around to correct this initial impression. For it is certainly not the impression Dante wishes to leave with us; or rather, it *is* an impression he wishes to produce — but properly understood. What he describes is the draining of all goodness and light and love.

In this dark hole, in the very center of the earth, there is barely a vestige of God left. There is nothing heroic about Dante's Satan, nothing even remotely glamorous about his indomitable will. He can't even get a simple word out, let alone indulge in the kind of lofty diatribes Milton's Satan is allowed. The slow bat-like movement of this Satan's wings, the noise of his gnawing on bone and gristle, the movement of his huge bat-like wings, which produces the icy winds that freeze Cocytus, are far removed from any vestige of Lucifer's former grandeur.

Still, Eliot is right in registering disappointment at first. All of us conditioned by Milton's Satan have to readjust our sights when we come to Dante. Seen against the topography of Hell, it is not difficult to do so. We are in No Man's Land, in a rocky cavern situated in the bowels of the earth; nothing compares to this place. And once our eyes have adjusted, we realize that the punishment of Satan is indeed *qualitatively* different. The full horror bears down on us as we take in the sub-human transformation he has suffered. No other sinner has been subjected to anything like it. The topography of the constricting claustrophobic space; the nature of the beast — a one-of-a-kind monster — his awful

aspect, the travesty of the divine trinity in the three horrible heads resting on one pair of shoulders, are all part of an ingenious unique description. To further understand the moral implications of all this, we should remember that in Canto XI of *Inferno* Dante reviews his outline, scraps his early design based on familiar transgressions, and announces an Augustinian buttressing for the rest of the *Inferno*.

The large upper circles of the incontinent, those who allowed the natural appetites to rule them, giving in to excesses, are followed by the circles of the violent and those of the fraudulent. Not only does this give Dante a chance to express more vividly his views on political matters, personal and public fraud and the like; it also dramatizes a much more profound theory, namely, that sin is not something substantive in itself but the emptiness, the squalor if you like, that comes with the absence of God's goodness and love. As we approach the very bottom of the pit, space grows more and more constricted, human attributes are more and more reduced to bestial sounds, normal exchanges become curses and invectives. We see nature undergoing a terrible transformation, both in the beings stuck in these places and in the barren rocky places themselves. Dante is draining the earth of everything good in it. This is surely symbolic but also real. The place reeks, the sounds are moans and curses, the sky is invisible and will continue to be hidden until the difficult journey into the bowels of the earth is over.

Still, even a vestige of life, no matter how misdirected, contains a measure of the divine by the sheer fact of its existence. And, Satan himself, so long as he can move his bat-like wings, shed his tears of frustration, so long as he metes out punishment on the arch-traitors, gnawing their bodies, is asserting the power and glory of God. In his own way and under the circumstances described, Satan in fact rules as

king, for Dante never lets us forget that the City of Dis belongs to Satan as the heavenly City belongs to God. Satan's realm is the drained equivalent of all goodness and love. In the total political context of the *Commedia* nothing could resonate more clearly and at the same time more harshly than such a juxtaposition.

Dante highlights special moments like the sight of Satan in decidedly unusual ways. He describes through a rich collection of similes his inability to tell us accurately what he saw and felt: he records his confusion, his disorientation, the darkness and heavy fog, which reduce visibility almost to zero, the sense of imminent danger. He stumbles and stutters in trying to make sense of all this; and we are alerted by his insistence on this difficulty to the double transcendence he is in fact illustrating: that both words and memory fail him at this point, that we are witnessing an *ecstatic* experience. He will use this technique again at the top of *Purgatorio* and at the top of *Paradiso*.

This insistence on an experience beyond words is enriched by clusters or families of images that together produce a vivid and unforgettable impression. All this against the Augustinian backdrop of God's presence in all things, even in the most despicable of sinners.

Seen as the dark antithesis of the light and love of God, Dante's Satan cannot fail to produce an impression at least as forceful as that produced by the "Byronic hero" of Milton's epic poem. The poetic language of the last canto of *Inferno* is no less dramatic than the language of *Paradise Lost*. Dante, with the sensitive touch of a true poet, recalls the main theme in a powerful minor key, using discordant notes and jarring sounds, silences even, to suggest the full exhaustion of the lyrical melody. For it is in the fullness of the poem seen and heard in all its architectural diversity, its echoing naves and its musical choirs, that every part is

enriched. The *Inferno* is the destructiveness of self-love, the negation of *caritas,* and Dante's Satan is the extreme expression of that self-love, forever asserting itself against God, cut off forever from the true nature of man, which is to seek happiness, certainty, and love, all of which guarantee the ultimate goal: freedom.

It is precisely *freedom* which Satan will never again know, in spite of his role as "lo imperador del doloroso regno."[13] Eliot eventually came to appreciate Dante's Satan. That portrayal reveals, he concluded, the same strokes of genius which make the last canto of the *Paradiso* the highest point that poetry has ever reached or ever can reach.[14]

The Beginning: Unanswered Questions

The number three and multiples of three serve in important ways in *The Divine Comedy*. There are nine circles in *Inferno,* nine heavens in *Paradiso*. There are three canticles each containing thirty-three cantos, with the exception of *Inferno,* which has an extra "introductory" canto, bringing the total number of cantos in the poem to a magic 100. We saw how the number three evokes more than once the Holy Trinity, even at the pit of hell; and without going into a long discourse on numerology and what Dante and his contemporaries believed with respect to the special meaning of numbers, we can safely say that he was well versed in the subject and made good use of it in his poem. In the opening canto of the *Inferno,* we are immediately faced with a threesome: symbolic beasts that represent the sins of mankind.

This first canto and the one that follows not only provide the blueprint for what is to come, they also introduce us to Dante the Florentine, Dante the man, who has just experienced a terrible ordeal and can barely speak about it.

Dante, the fabulous story-teller, begins by recalling his breathless escape from a dark wood. He is full of fear, his

heart pounding at the mere thought of what he had endured there. He doesn't go into details. He doesn't have to. He is telling his listeners to fill in whatever it is that they've experienced in that way, whatever terrors have plagued them. In a way, we are already in a scenario in which Dante is also Everyman.

He tells us all this happened in the middle of his life, which means he was thirty-five at the time, half the biblical seventy considered then, as now, the natural span of life. We learn soon enough that it is Good Friday of the year 1300 (the entire journey covers that one weekend). The opening lines set the fast pace and the horror and mystery which characterize the *Inferno*.

> In the middle of life's journey,
> I found myself in a dark wood,
> The right path completely lost.
> Ah, to tell about that savage, harsh, thick wood
> Is a hard task, the very thought renews my fear!
> So bitter, death is hardly more;
> But to deal with the good I found in there,
> I must relate the other things I saw.

> Nel mezzo del cammin di nostra vita
> Mi ritrovai per una selva oscura,
> Chè la diritta via era smarrita.
> Ah quanto a dir qual era è cosa dura
> Esta selva selvaggia e aspra e forte,
> Che nel pensier rinnova la paura!
> Tant' è amara che poco è più morte;
> Ma per trattar del ben ch' io vi trovai,
> Dirò de l' altre cose ch' io v' o scorte.

Having established the mood, having introduced the mystery, he rushes on to bring us into the present while still lingering on the nightmare experience he has referred to. In these lines, Dante is speaking clearly as the protagonist

rather than the narrator. He is telling us how he personally went astray. The words he uses are transparent and direct; we can easily grasp the implications and connotations of *dark, thick wood* or *forest, sleep, the right path,* and so on. Without for a moment breaking through the delicate poetic fabric, he describes in the simplest language an experience that is anything but simple.

> I can't really tell how I got there,
> I was so full of sleep at that point
> Where I left the true road.
> Then coming to the foot of a hill
> Where that valley ended that had filled
> My heart with fear,
> I looked up and saw its shoulders
> Already draped in the rays of the planet
> That everywhere leads men to the right path.
> Then the fear that had flooded
> My heart all through that night
> So piteously spent, subsided somewhat.
> And as one who comes panting out of the sea
> On to the shore, looks back
> To stare at the dangerous waters,
> So my soul, still running, turned to view
> The pass no living soul
> Had ever left before.

> Io non so ben ridir com' io v' entrai;
> Tant' era pieno di sonno a quel punto
> Che la verace via abbandonai.
> Ma poi ch' i' fui al piè d' un colle giunto,
> Là dove terminava quella valle
> Che m' avea di paura il cor compunto,
> Guardai in alto, e vidi le sue spalle
> Vestite già de' raggi del pianeta
> Che mena dritto altrui per ogni calle.
> Allor fu la paura un poco queta
> Che nel lago del cor n' era durata
> La notte ch' io passai con tanta pieta.

E come quei che, con lena affannata,
 Uscito fuor del pelago a la riva,
 Si volge a l' acqua perigliosa e guata,
Così l' animo mio, ch' ancor fuggiva,
 Si volse a rietro a rimirar lo passo
 Che non lasciò già mai persona viva.

Quickly Dante gets his bearings and starts walking across the deserted area toward the mountain whose top is already bathed in morning light, but suddenly, out of nowhere, three beasts appear in his path. The first is a leopard, the symbol of all human lusts and cravings; the second is a lion, the symbol of pride; the third is a she-wolf, thin with unappeased cravings, and of the three the most relentless in preventing Dante's progress. Whatever hope Dante may have had of finding a new path out of that deserted place after the ordeal of the night and the terrors of the dark wood is shattered by this third beast, who keeps circling around him, forcing him back, bent on destroying him. This third beast, most critics agree, represents corrupt political ambitions, the ineffectual leadership that blocks the road to salvation.

The restless beast brought new terror
As it approached me, forcing me back
Little by little to where the sun is silent.

Tal mi fece la bestia senza pace,
 Che' venendomi incontro, a poco a poco
 Mi ripigneva la dove 'l sol tace.

"Forcing me back . . . to where the sun is silent." In one small phrase Dante has set the measure of the poetic suggestivity which will be maintained throughout the poem. Where is it that "il sol tace"? The dark wood, of course. The beast is pushing him back into the place from which he has just escaped, the place where there is no sun to speak to him,

to tell him what direction to take, where to go. But there are other layers of meaning. The sun is the symbol of God, of knowledge, of illumination, and therefore where the sun is silent there is no possibility of pursuing knowledge or the will of God. And much more.

We never quite know how Dante managed to get past the first two beasts — no doubt he is telling us that he was able on his own, with discipline and prayer, to control his appetites and curb his pride — but the third beast is more than he can handle. He needs help. And it is at this moment that Virgil appears. At first Dante doesn't know who it is. All he knows is someone, thank God, is there to help him. He cries out to the stranger. All this in just a few tight lines.

Virgil identifies himself and asks what one might expect him to ask: "Why are you going back there, after all you've been through? Why don't you climb the mountain in front of you?"

The drama that follows is, again, a personal one. Dante, wide-eyed at the improbable and utterly unexpected appearance of the great poet who was his life-long poetic guide and mentor, the poet who shaped his own new style, can only respond with surprise and questions. Only when identities have been established and proper praise bestowed on the great poet of Rome, does Dante refer to the beast still blocking his path. At this point, Virgil quickly moves into the major business at hand, which after all has already been decided elsewhere. He is not there casually. Nor can he urge Dante to climb that sunny mountain, the symbol of meditation, perhaps. Dante is programmed for something else.

He must go another way, on another journey for which he, Virgil, will act as his guide, until someone else will take over. In lines 112 to123 he gives a thumbnail sketch of the horrors they are about to experience; and he ends by explaining why he can't go further than a certain point, since he is a

pagan, relegated to Limbo. Dante, exhilarated and full of new hope and trust, quickly agrees to follow his beloved Virgil.

Not until the second canto does Dante question his having been chosen in this special way for the journey through the afterlife. The presence of Virgil triggered his initial questions, but he must have more answers before he can feel confident. And so he asks Virgil: Why me? I'm not Aeneas, who founded Rome; I'm not Paul, who shaped early Christianity. Those two were shown the realms of the dead for reasons that are pretty obvious. I will look foolish, presumptuous even, in taking on such an important undertaking. I'm not Aeneas; I'm not Paul. So, why me?

And here the poem takes a new turn: Dante now becomes Everyman as well as the Narrator and the Protagonist of the poem. Because, as Virgil explains, Dante indeed has a divinely ordained mission. Virgil's appearance was not an accident. From the very top of *Paradiso,* The Blessed Mother herself took the initiative and called upon Lucy — the patron saint of sight, vision, eyes, illumination, enlightenment — to rescue Dante; Lucy, in turn, sought out Beatrice, who actually went down into Limbo, the place where Aeneas resided, and with tears in her eyes, pleaded for his help in saving her faithful lover.

These three holy women help Dante escape from the three beasts. Beatrice ends her little speech to Virgil with the first deep chord of what will be one of the major themes of the poem: *Love.*

> "Love moved me, makes me speak."

> "Amor mi mosse, che mi fa parlare."

Love of God is what moves the stars and the other planets.

Love of Goodness is what enables the penitents in *Purgatorio* to bear their punishment willingly. Misguided love is what brought Paolo and Francesca to their romantic hell.

This is another incredible moment, in which we are lulled, distracted into thinking that everything finally has been straightened out. Not really. Dante, inspired by the fact that Beatrice has taken it upon herself to plead for him with Virgil, glosses over the fact that his big question remains unanswered. True, Beatrice nudged by Lucy, who was called to do what she did by the Virgin Mary, gives Dante the faith he needs to go on. But not until the very top of *Purgatorio,* when Dante the Protagonist reappears briefly for his new baptism, his new spiritual *vita nuova,* his reunion with Beatrice (who has just replaced Virgil), is the extent and importance of his mission finally made clear. He is to observe carefully the historical pageant before him, Beatrice tells him, and to record it faithfully in his memory so that he can report what he has seen and heard back to the world that lives ill. His mission has a purpose that is more than personal salvation.

Dante's initial humility seems to have given way to more than a touch of arrogance. In fact, here and elsewhere, his own standards and preferences seem to be the true measure of things. In his encounter with Beatrice, two-thirds of the way into the poem, it is clear not only that Dante has a great mission ordained by heaven itself, but he personally will be saved (something anathema in Catholic doctrine). He introduces as the guardian of *Purgatorio* Cato, a pagan and a suicide. Throughout the ledges of *Purgatorio,* and elsewhere, he draws examples from pagan as well as Christian sources. The presence of Virgil himself may raise some questions in this context.

Moreover, throughout his configuration of *Inferno* he creates his own ingenious punishments, puts people in places

designed by his fertile imagination, gives historical basis to events not altogether clear in his own day. In short, he has created places and even people that fit nicely into a schemata of his own, especially where political corruption is the subject. We accept all this because it is *consistent,* it is *reasonable,* and, most important, it is *poetically mesmerizing.* Whatever novelties he introduces, however, Dante never undermines Christian sensibilities.

V. Some Observations on DANTE IN AMERICA AND THREE MAJOR BRITISH POETS INFLUENCED BY DANTE

The list of poets, writers, and scholars throughout the world who have been drawn to Dante over the centuries is too long to be discussed here (Boccaccio was the first to take on the poem in a series of lectures in Florence); but one must at least mention in this context the tremendous impact Dante had on American literature from the very beginnings of our nation, when a young America was struggling to define its new independent identity.[15] We recall especially that eminent group of Harvard scholars and teachers, at the beginning of the nineteenth century, whose enthusiasm resulted in excellent translations and scholarly appraisals of Dante's work; as well as later writers, right down to our own time. Even a partial list is impressive: Henry Wadsworth Longfellow, James Russell Lowell, Charles Eliot Norton, Charles H. Grandgent, W. T. Harris, Allen Tate, Francis Fergusson, Thomas G. Bergin, John Freccero, Charles S. Singleton, Robert Hollander, and perhaps the most eminent of America's Dante scholars and teachers, Dino Bigongiari, who taught at Columbia University for over half a century.

Even more impressive are the innovative readings and interpretations of Dante's lines by other poets. Pre-Raphaelites like William Morris and Dante Gabriel Rossetti

were deeply influenced by the idealized figure of Beatrice, who is often the subject of their paintings and verse. A century earlier, the greatest of the English Romantic poets, Shelley, had come under Dante's spell, giving us, in addition to much else inspired by Dante, a magnificent English translation of one of his favorite passages: the description of the new Eden at the top of Purgatory.[16] It is the moment when the long-awaited Beatrice finally appears, as had been promised at the opening of *Inferno*. She has been sent to replace Virgil as Dante's guide and to see him safely through the rites of passage that prepare him for the true *vita nuova*. That brief excerpt is one of the most limpid and beautiful renditions ever made of the Italian text into English. A century later, the *Inferno* serves as inspiration for James Thomson's *The City of Dreadful Night,* what one critic has called "the most pessimistic poem in English." Thomson actually opens his poem with a quotation from the first Canto of the *Inferno.*

In our own time, it is T. S. Eliot, the American-born British poet, who deserves to be singled out for his life-long appreciation of Dante. In a talk delivered at the Italian Institute in London in 1950, the great poet/critic of our century admitted: "I still, after forty years, regard [Dante's] poetry as the most persistent and deepest influence upon my own verse . . ."[17] This statement, from the author of *The Wasteland,* the most celebrated poem of the twentieth century, confirmed what many critics already had come to realize, that Eliot not only patterned his modern hell after Dante's *Inferno,* but also used many of Dante's lines and poetic habits in his major poem as well as in other works like "Little Gidding." Eliot's description of the modern world as a Dantesque hell has made the *Inferno* immediately accessible to readers of our time. *The Wasteland* sums up the existential aftermath of two major wars; it dispels the illusory optimism

generated by social reform as the answer to mankind's ills; it strips away false hopes.

It is a powerful statement for our secular age; but Dante says it best, and for all time.

NOTES

1. Dorothy L. Sayers, *Further Papers on Dante* (London, Methuen & Co. Ltd., 1957), p. 10.

2. *Ibid.,* p. 15.

3. *Ibid.,* p. 2.

4. *Ibid.,* p. 7.

5. *Ibid.,* p. 9.

6. *Ibid.,* p. 6.

7. *Ibid.,* p. 9.

8. The shepherd is the Pope, of course. The injunction in regard to clean and unclean beasts was familiar to the schoolmen. St. Augustine talks about the cloven hoof as symbolic of right conduct because it does not slip easily; and he interprets the chewing of the cud to signify wisdom.

9. The struggle for precision is at the heart of every effort at translation, but even the best efforts sometimes create difficulties. At the risk of falling into the very error I've mentioned, I have used my own informal English version for the Italian passages quoted here.

10. C. H. Grandgent, ed., *La Divina Commedia* (Boston, New York, etc., D. C. Heath and Company, 1933), *Purgatorio,* Canto XVI, ll. 66-114.

11. Canto XXXIV, l. 25.

12. T. S. Eliot, "Dante," *Selected Essays,* 1917-1932 (New York, 1932), p. 212.

13. Canto XXXIV, l. 28.

14. Eliot, p. 212.

15. A. Bartlett Giammati, ed. *Dante in America: The First Two Centuries* (Medieval & Renaissance Texts & Studies, Binghamton, New York, 1983).

16. Shelley, *Selected Writings.*

17. T. S. Eliot, "A Talk on Dante," in *Dante in America: The First Two Centuries,* p, 219.

REPRODUCTIONS

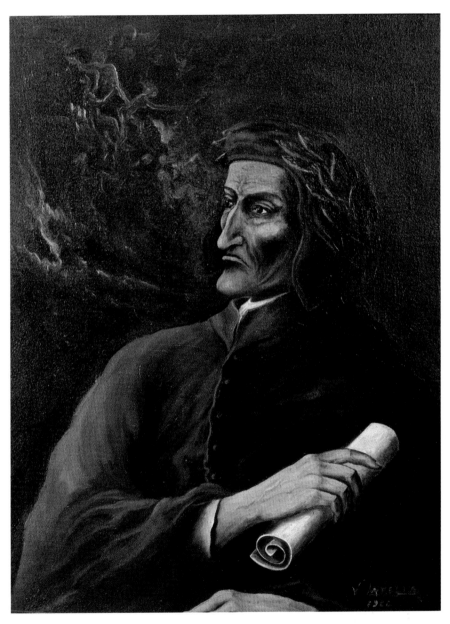

DANTE ALIGHIERI
1265–1321

Nel mezzo del cammin di nostra vita
mi trovai per una selva oscura,
che la diritta via era smarrita.
Canto I, 1-3

In the middle of life's journey
I found myself in a dark wood,
the right path completely lost.

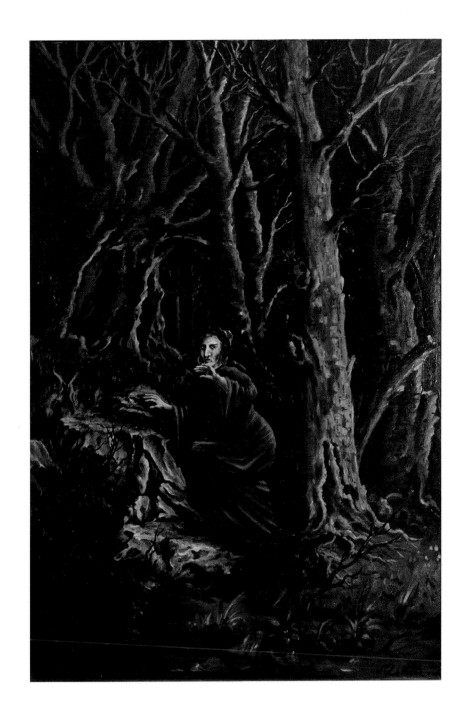

"Or va, ch' un sol volere è d'ambedue:
 tu duca, tu segnore, e tu maestro."
 Così li dissi; e poi che mosso fue,
intrai per lo cammino alto e silvestro.
 Canto II, 139-142

"Lead on, a single will now governs both of us:
 my leader, my lord, my master."
 Those were my words; and when he moved ahead
I entered the thick and savage wood.

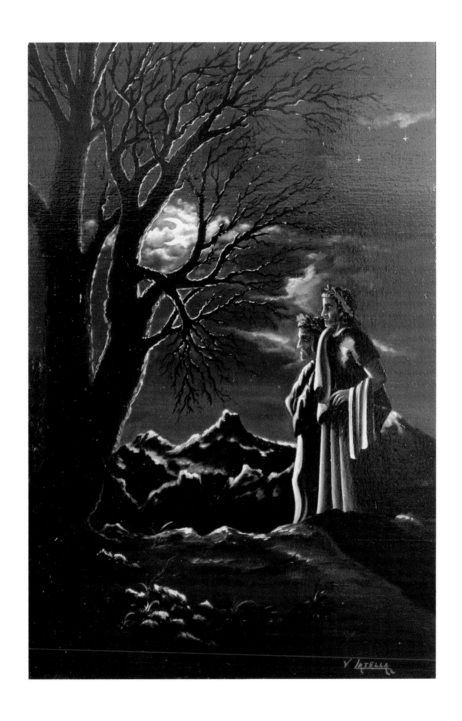

47

DINANZI A ME NON FUR COSE CREATE
SE NON ETERNE, E IO ETERNA DURO.
LASCIATE OGNI SPERANZA, VOI CH'ENTRATE.
Canto III, 7-9

BEFORE ME, NO THING CREATED WAS
IF NOT ETERNAL, AND I SHALL LAST ETERNAL.
ABANDON EVERY HOPE, YOU WHO ENTER.

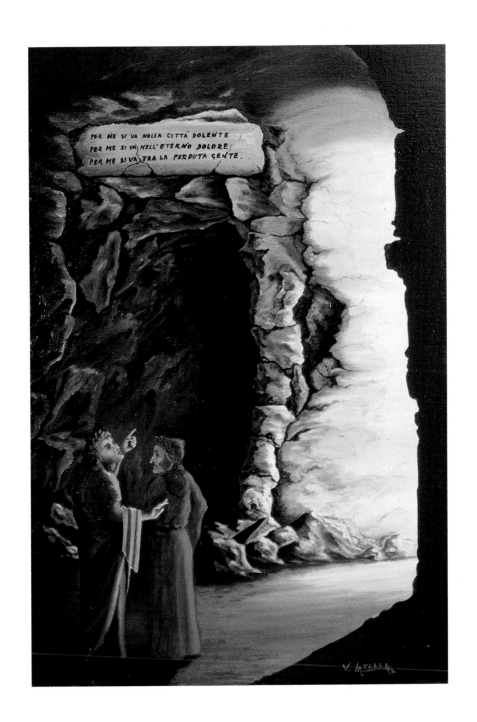

Vero è che 'n su la proda mi trovai
 de la valle d'abisso dolorosa,
 che truono accoglie d'infiniti guai.
 Canto IV, 7-9

All I can tell you is, I found myself on the edge
 of the deep and woeful pit
 that echoes with the moans of endless grief.

50

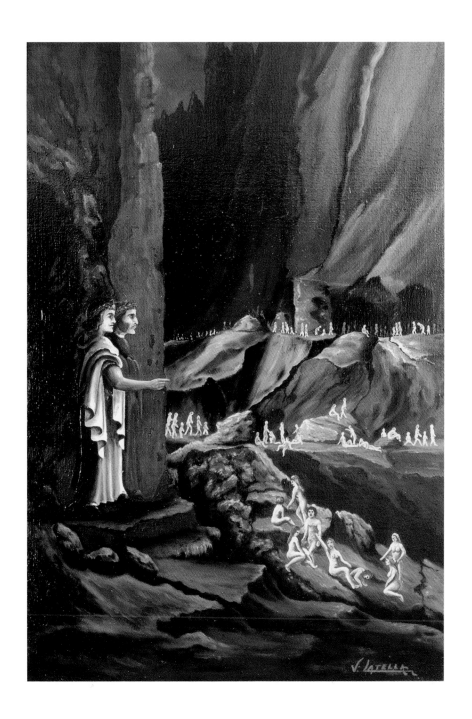

Amor, ch'a nullo amato amar perdona,
mi prese del costui piacer sì forte,
che, come vedi, ancor non m'abbandona.
Canto V, 103-105

Love, that excuses no one from loving in return,
took hold of me with such delight,
that, as you see, it has not yet abandoned me.

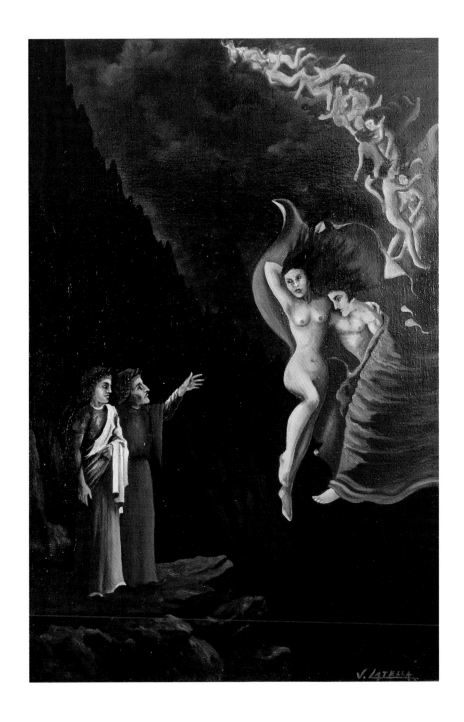

"Voi cittadini mi chiamaste Ciacco:
 per la dannosa colpa de la gola,
 come tu vedi a la pioggia mi fiacco."
 Canto VI, 52-54

"You people called me Ciacco:
 my damnable gluttony is why, as you see,
 I'm wasted by this rain"

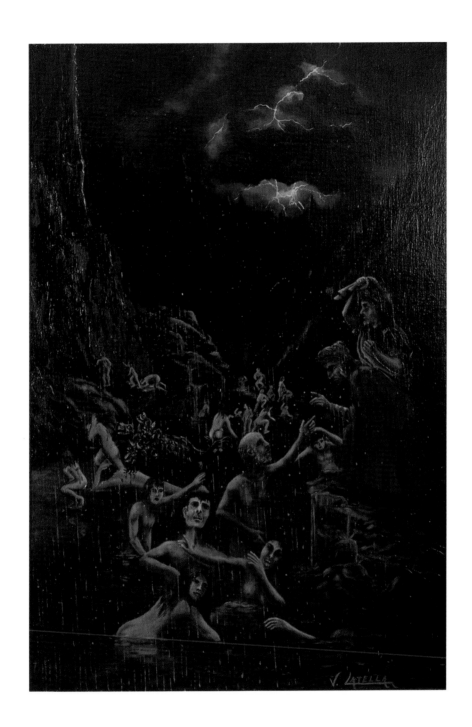

E io, che di mirare stava inteso,
 vedi gente fangose in quel pantano,
 ignude tutte, con sembiante offeso.
 Canto VII, 109-111

And I, rooted there, staring,
 saw in the mire a mob of people, all naked,
 covered with mud, their faces
 betraying their degradation.

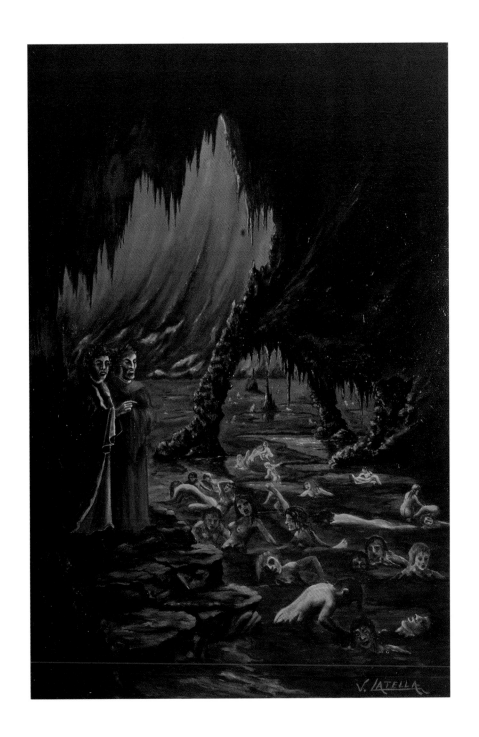

Tosto che 'l duca e io nel legno fui,
 segando se ne va l'antica prora
 de l'acqua più che non suol con altrui.
 Canto VIII, 28-30

As soon as my guide and I were in the boat,
 the ancient prow edged out, cutting
 the water more deeply than
 if others were on board.

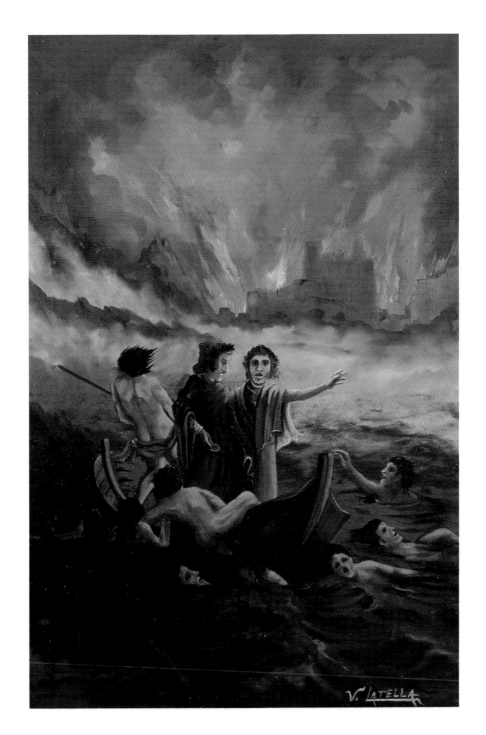

Ahi quanto mi parea pien di disdegno!
　Venne a la porta, e con una verghetta
　l'aperse, che non v' ebbe alcun ritegno.
　　　　　Canto IX, 88-90

Oh, what scorn was in his look!
　He came to the gate and opened it
　with a tiny wand, with no resistance from any side.

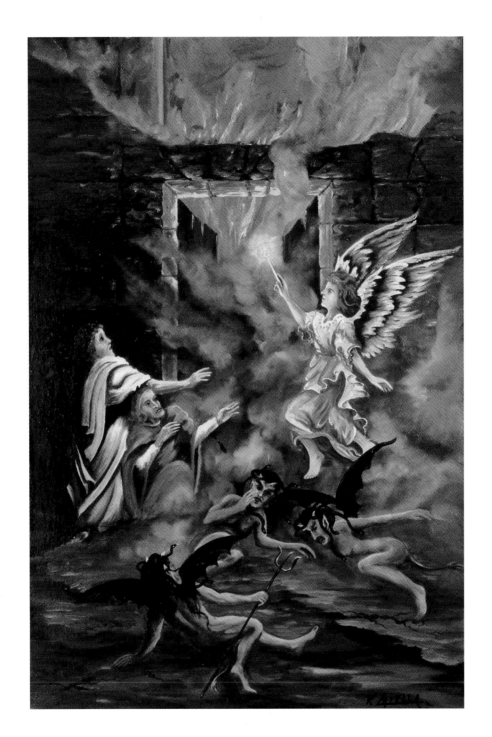

"O tosco che per la città del foco
 vivo ten vai così parlando onesto,
 piacciati di restare in questo loco.
 Canto X, 22-24

"O Tuscan, moving through the city of fire,
 like this, though still alive, with easy speech,
 pause here a moment, if you would"

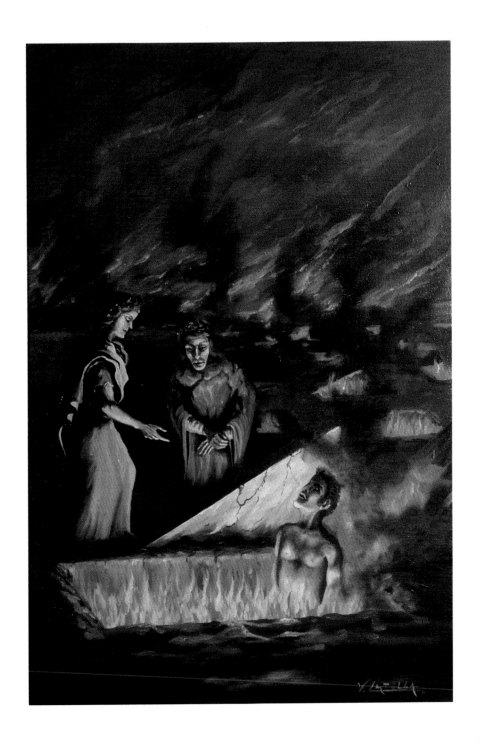

.... e quivi, per l'orribile soperchio
del puzzo che 'l profondo abisso gitta,
ci raccostammo in dietro ad un coperchio
Canto XI, 4-7

And here the overpowering stink that rose
from those lower depths
forced us to seek refuge behind the cover
of a massive vault

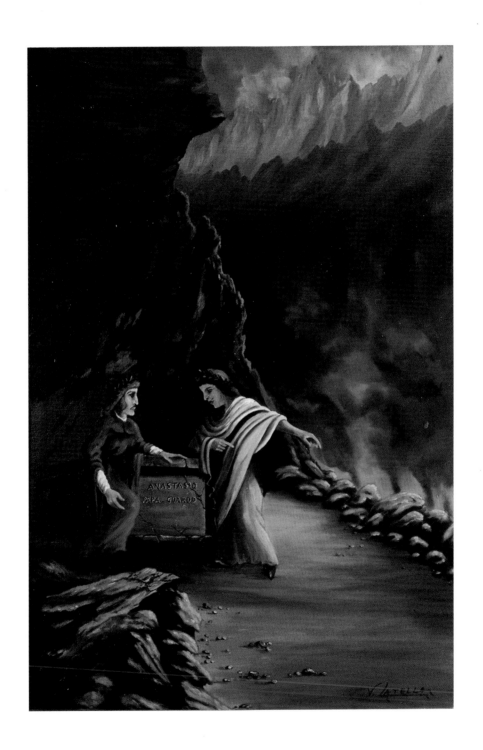

65

"Siete voi accorti
 che quel di retro move ciò ch' el tocca?
Così non soglion fare i piè de' morti."
 E 'l mio buon duca, che già li era al petto,
 dove le due nature son consorti,
rispuose: "Ben è vivo "
 Canto XII, 80-85

"Have you noticed
 how the one behind moves what he touches?
Dead men's feet don't do that."
 And my good guide, already by his chest,
 where the two beings were joined as one,
replied: "Indeed, he is alive "

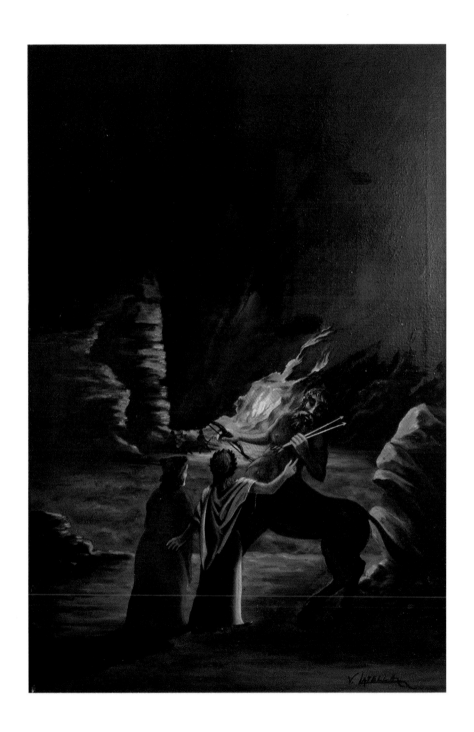

Di retro a loro era la selva piena
di nere cagne, bramose e correnti
come veltri ch'uscisser di catena.
Canto XIII, 124-126

Behind them the woods were full
of black bitches, eager, running
like hounds set loose from their chains.

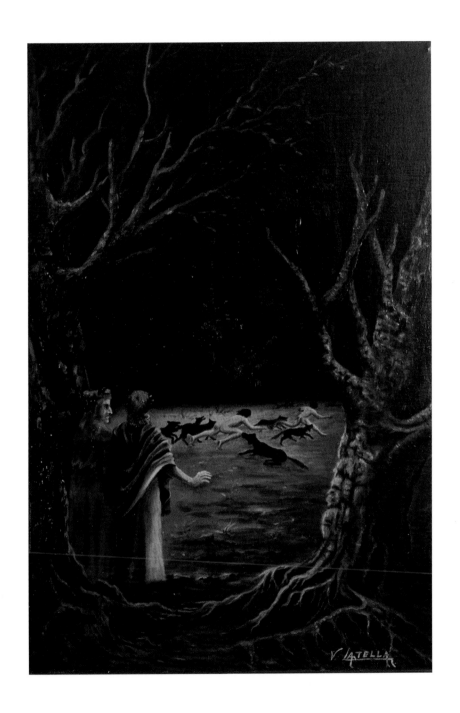

Sovra tutto 'l sabbion, d'un cader lento,
 piovean di foco dílatáte falde,
 como di neve in alpe senza vento.
 Canto XIV, 28-30

Over the whole stretch of sand,
 large flakes of fire fell slowly,
 like snow in the alps when there's no wind.

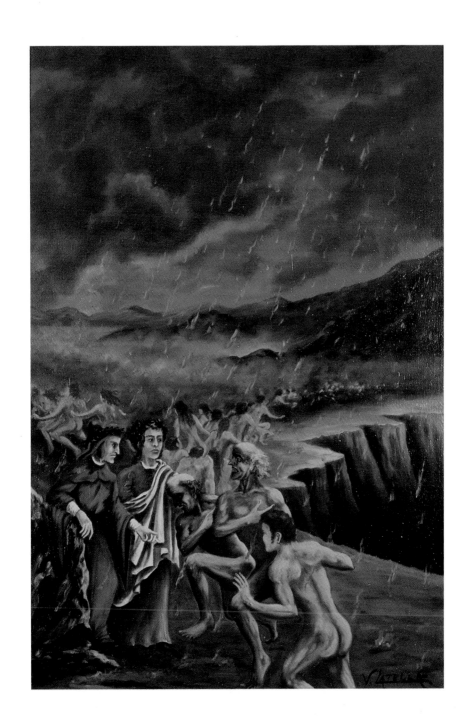

. . . quando incontrammo d'anime una schiera,
che venìan lungo l'argine, e ciascuna
ci riguardava, come suol da sera
Canto XV, 16-19

. . . we ran into a crowd of souls
hurrying along the bank, each one
turning to look, like one peers at a person
at night, under a new moon

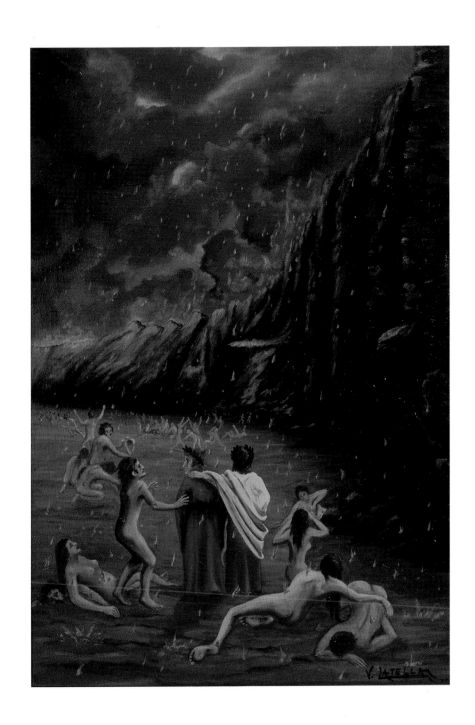

 . . . vidi per quell'aere grosso e scuro
venir notando una figura de suso,
maravigliosa ad ogni cor sicuro
 Canto XVI, 130-132

 . . . I saw swim upward through
the dark murky air a shape
even the staunchest heart must shudder at

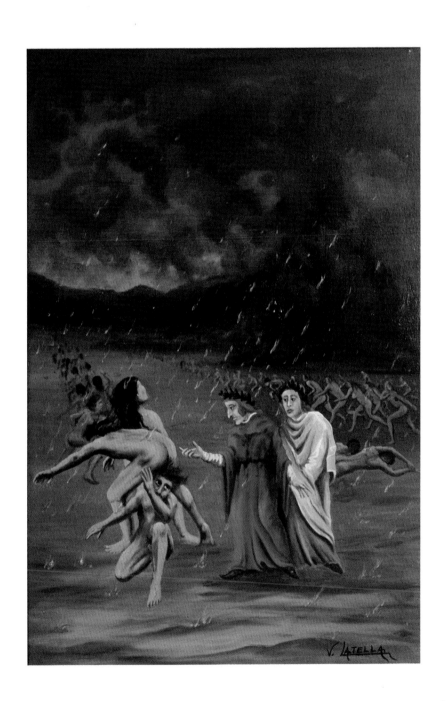

. . . così ne pose al fondo Gerïone
 al piè al piè de la stagliata rocca;
 e, discarcate le nostre persone,
si dileguò, come da corda cocca.
<div align="right">Canto XVII, 133-136</div>

. . . Geryon deposited us at the very foot
 of the steep cliff-face,
 and having unburdened himself of us,
shot off, as from a drawn bow.

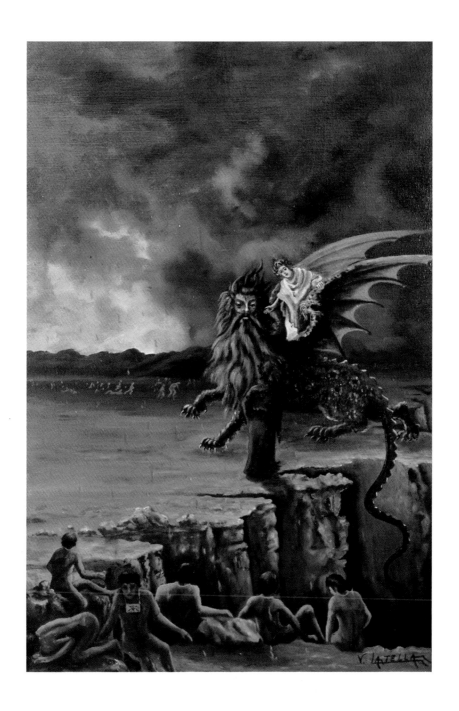

In questo luogo, de la schiena scossi
di Gerïone, trovammoci; e 'l poeta
tenne a sinistra, e io dietro mi mossi.
Canto XVIII, 19-21

Having been shaken off by Geryon
we found ourselves in this place; and the poet
moved toward the left, and I was right behind him.

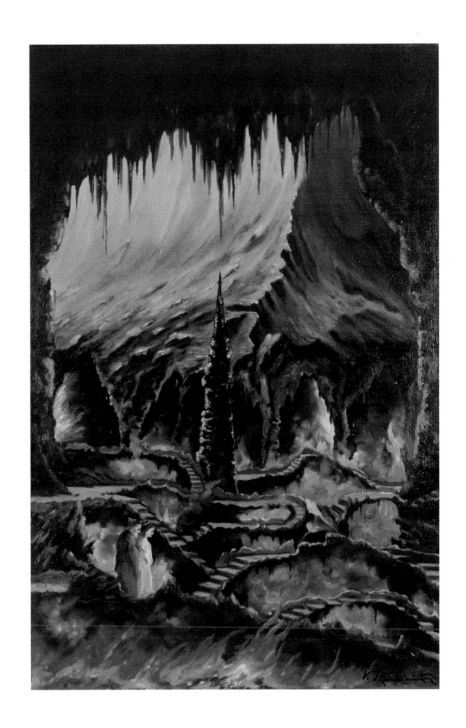

Fuor de la bocca a ciascum soperchiava
 d'un peccator li piedi e de le gambe
 infino al grosso; e l'atro dentro stava.
 Canto XIX, 22-24

From the mouth of each hole, a sinner's feet
 and legs stuck out, up to the calf,
 the rest remained inside.

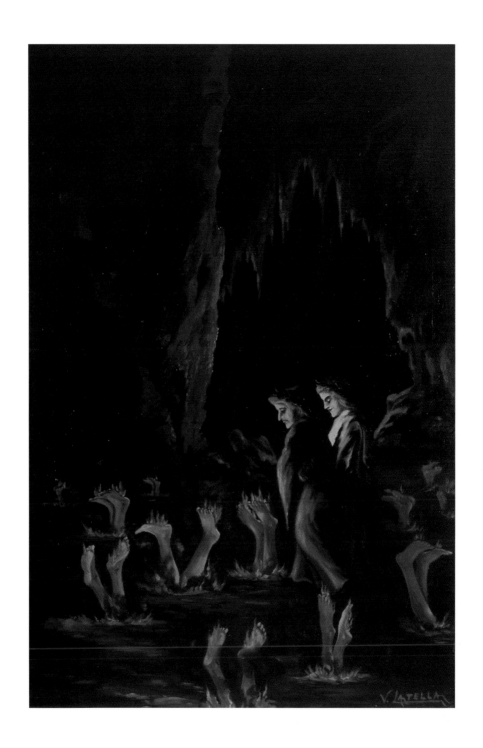

. . . ché de le reni era tornato il volto,
ed in dietro venir li convenia,
perchè 'l veder dinanzi era lor tolto.
 Canto XX, 13-15

. . . the face of each was twisted round
so that they had to walk backwards,
because looking ahead was denied them.

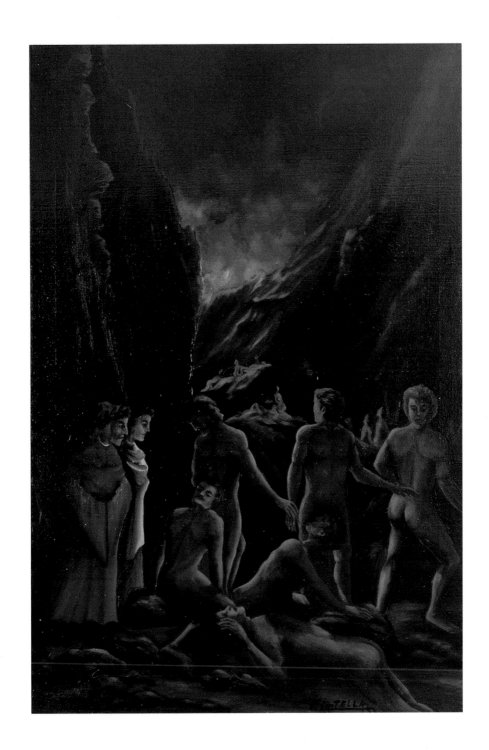

"Credi tu, Malacoda, quì vedermi
 esser venuto," disse 'l mio maestro,
 "sicuro già da tutti vostri scherni,
sanza voler divino e fato destro?
 Lascian' andar, chè nel cielo è voluto
 ch'i' mostri altrui questo cammin silvestro."
 Canto XXI, 79-84

"Do you suppose, Malacoda," said my master,
 "you would be seeing me here,
 untouched by all your tricks,
without divine will and destiny wanting it?
 Allow us to pass, for it is heaven's will
 That I show him this savage place."

84

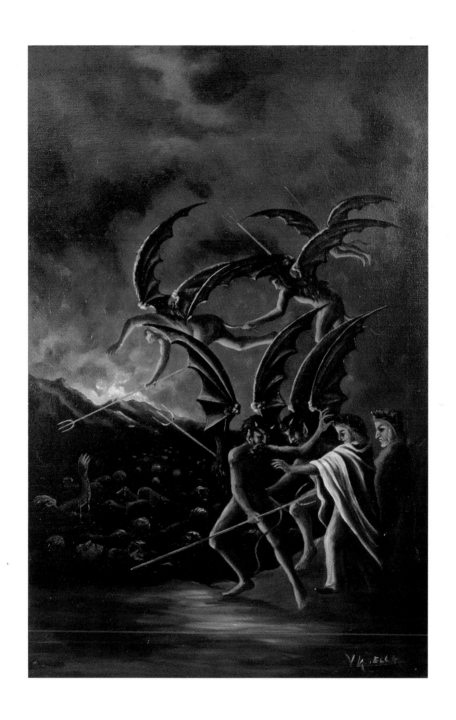

 . . . l'ali al sospetto
non potero avanzar; quelli andò sotto,
e quei drizzò, volando suso, il petto.
 Canto XXII, 127-129

 . . . wings could not fly
swifter than fear; the one plunged down,
the other straightening up, flew above him.

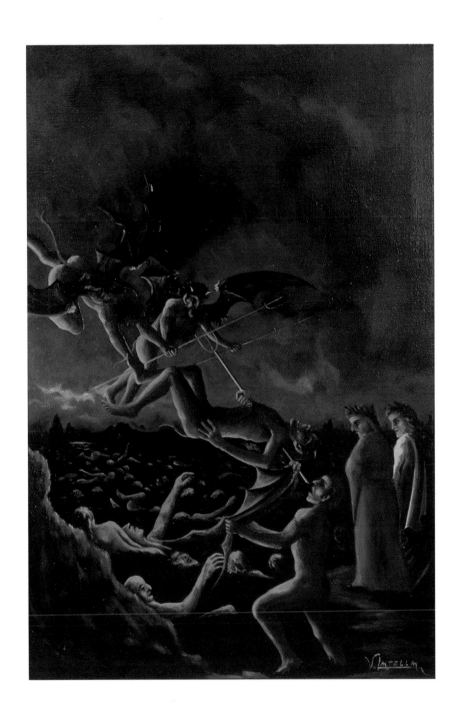

Taciti, soli, senza compagnia
 n'andavam, l'un dinanzi e l'altro dopo,
 come i frati minor vanno per via.
 Canto XXIII, 1-3

Quiet, alone, with no company,
 we kept on walking, one behind the other,
 like monks walking down the road.

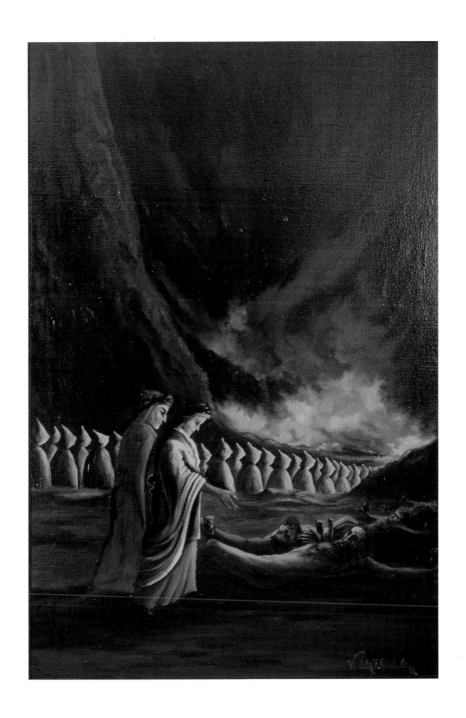

. . . e poi che fu a terra sì distrutto,
la polver si raccolse per se stessa,
e 'n quel medesmo ritornò di butto.
Canto XXIV, 103-105

And after he was scattered thus upon the ground,
the dust stirred and gathered together by itself,
and in a flash returned to what it was before.

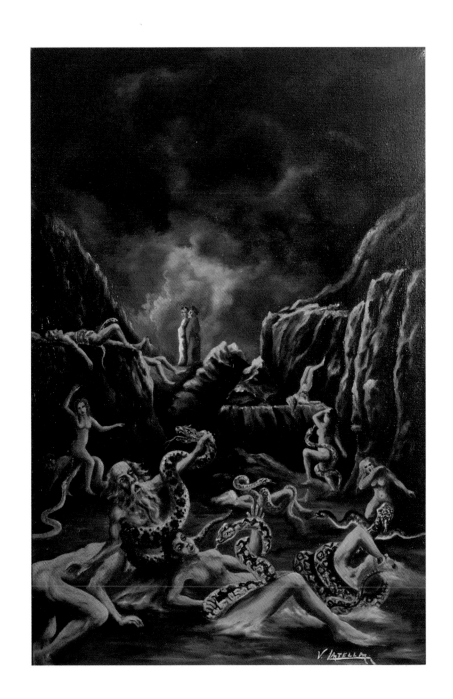

Lo mio maestro disse: "Questi è Caco,
 che sotto il sasso di monte Aventino
 di sangue fece spesse volte loco."
 Canto XXV, 25-27

My master said: "This is Cacus,
 who often turned the cave under the Aventine hill
 into a lake of blood.

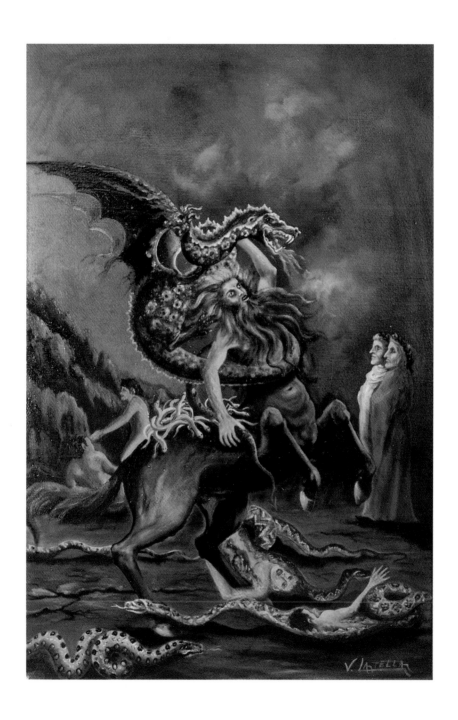

Rispuose a me: "Là dentro si martira
Ulisse e Diomede, e così insieme
a la vendetta vanno come l'ira."
Canto XXVI, 55-57

He answered: "Ulysses and Diomede
suffer together there, joined in their
punishment as in their crime."

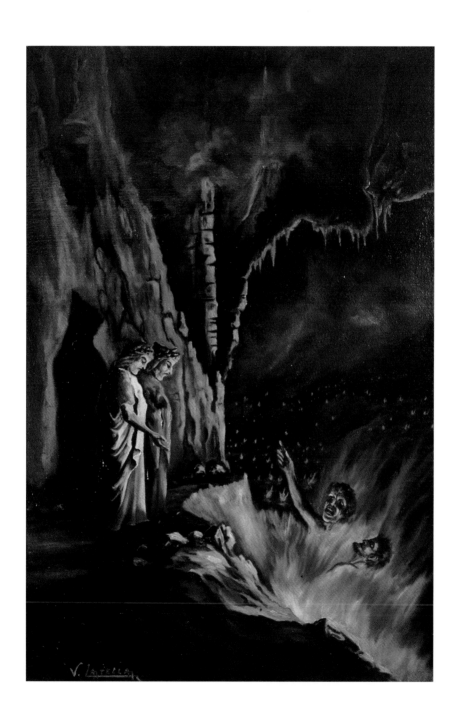

Io era in giuso ancora attento e chino,
 quando 'l mio duca mi tentò di costa,
 dicendo: "Parla tu; questi è latino."
 Canto XXVII, 31-33

I was still bent, deep in thought, my head down,
 when my guide nudged me,
 saying: "You talk, this one is a Latin."

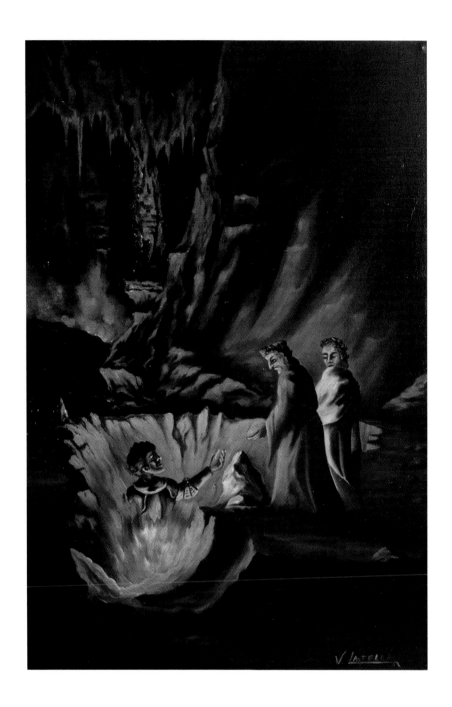

Di sè facea a se stesso lucerna,
 ed eran due in uno e uno in due;
 com'esser può, quei sa che sì governa.
 Canto XXVIII, 124-126

His own self cast light upon himself,
 two in one and one in two; how that could be
 he alone can know, who so rules.

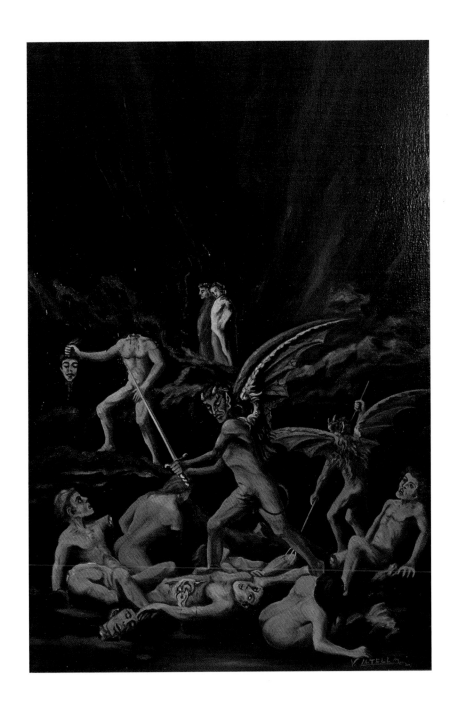

La molta gente e le diverse piaghe
 avean le luci mie sì inebriate,
 che de lo stare a piangere eran vaghe
 Canto XXIX, 1-3

The crowd of people and their strange wounds
 had brought such tears to my eyes
 that I was ready to just stand there crying

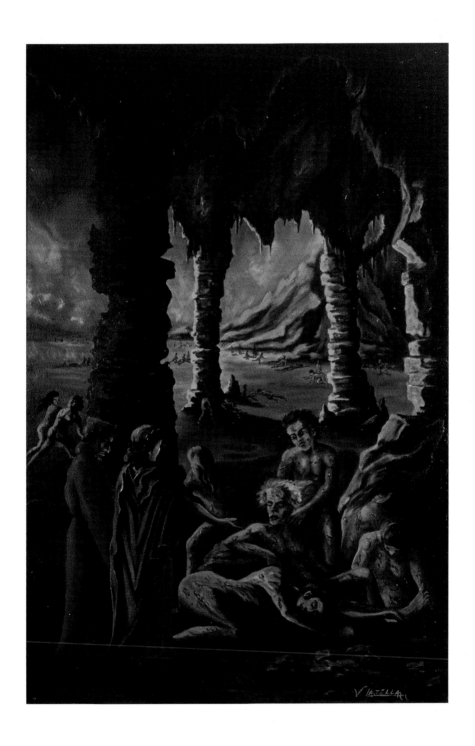

Ma né di Tebe furie né troiane
 si vider mai in alcun tanto crude,
 non punger bestie, non che membra umane,
 Canto XXX, 22-24

But never did any Theban or Trojan fury
 jab either beasts or human limbs
 with such cruelty.

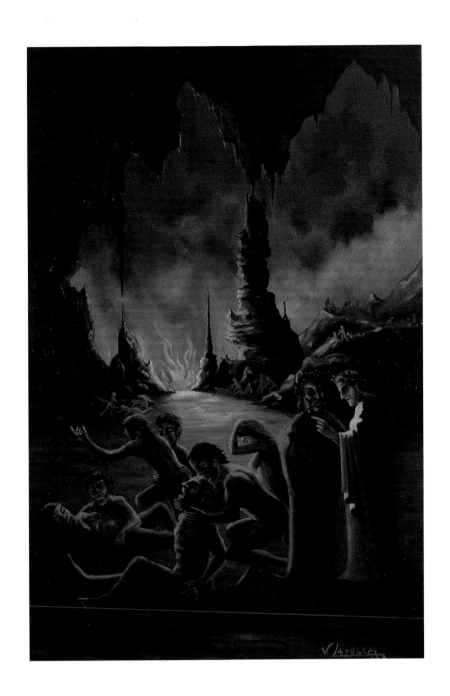

Virgilio, quando prender si sentio,
 disse a me: "Fatti qua, sì ch'io ti prenda";
 poi fece sì, ch'un fascio er'elli e io.
 Canto XXXI, 133-135

When Virgil felt them grabbing him,
 he said to me: "This way, so I can reach for you."
 He clutched me then, the two of us entwined as one.

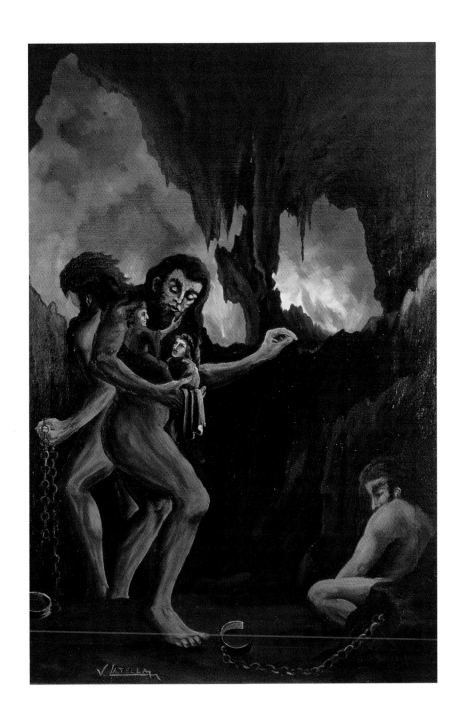

Per ch'io mi volsi, e vidimi davante
e sotto i piedi un lago che per gelo
aveva di vetro e non d'acqua sembiante.
Canto XXXII, 22-24

At that I turned, and saw in front of me
and under my feet a lake of ice so solid
it looked like glass rather than water.

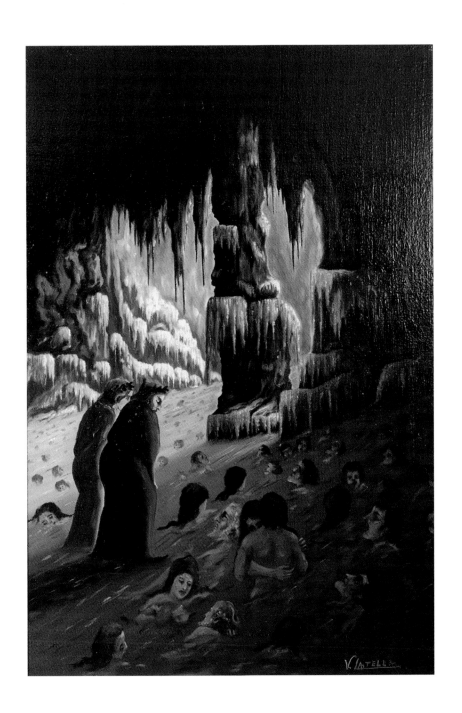

La bocca sollevò dal fiero pasto
 quell peccator, forbendola a' capelli
 del capo, ch'elli avea di retro guasto
 Canto XXXIII, 1-3

Lifting his mouth from that bestial meal,
 the sinner wiped it on the hair
 of the very head he had been crunching on

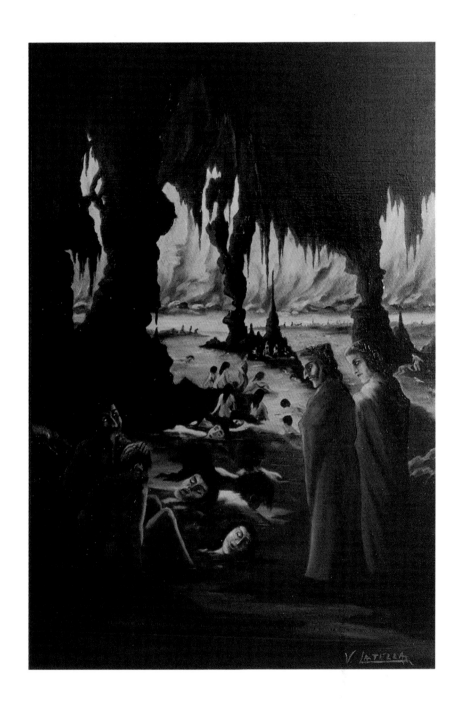

. . . salimmo su, el primo e io secondo,
tanto ch'i' vidi de le cose belle
che porta 'l ciel, per un pertugio tondo;
e quindi uscimmo a riveder le stelle.

Canto XXXIV, 136-139

. . . we climbed up, he leading, I behind,
until, through a round opening, I glimpsed
some of the beautiful things of the sky;
and then we came outside to see the stars again.

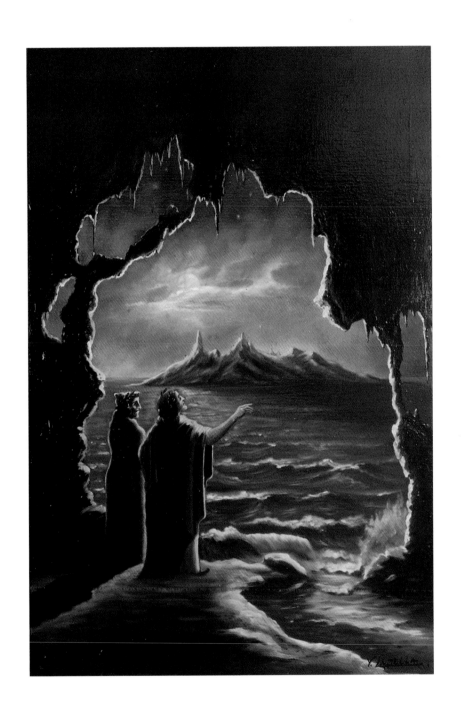

111

BIOGRAPHICAL NOTE

VINCENZO R. LATELLA

Vincent Latella was born in Bagnara, Calabria, Italy, on March 25, 1929. From his youth he showed artistic tendencies.

At twenty-one, Latella enrolled at the Academy of Art in Rome, where he studied design and painting and graduated with high honors. He later moved to Turin, where he studied and worked with Professor Mario Micheletti. During this time, he was given numerous commissions for church frescoes and paintings. The experience helped him to perfect his technique and develop a characteristic style.

"When I paint," Mr. Latella explains, "1 don't look for new ideas but draw from thoughts I've nurtured over the years and which find confirmation on the canvas." Inspiration is ultimately from within the artist, he insists, not an external jolt; experience is important but must always be translated into an internal reality. And in order to give inspiration the best possible expres-

sion, the artist must perfect his skills and hone his God-given talent to perfection.

Mr. Latella participated in the "Promotion of the Fine Arts in Turin" and was exhibited at the Caurrina Hall of Turin, the Mostra Pittorica Nazionale of Carrara (where he won a prize), the "Mezzo Agosto Bagnarese," and Bagnara's "La Pro Loco." In a ceremony honoring the most important and best representatives in a variety of professions and activities — film, photography, sports (swimming champions, sports personalities, soccer teams), etc. — Bagnara singled out Mr. Latella, honoring him with a citation for excellence in the field of art.

In 2000, Mr. Latella took part in an exhibit of Italian painters, sponsored by Studio d'Arte Il Ponte (Rome) at Le Carré D'Or (Paris), which, in January 2001, was brought to the United States and was seen at the ART GALLERY OF QUEENSBOROUGH COMMUNITY COLLEGE OF THE CITY UNIVERSITY OF NEW YORK. In the United States, his work includes frescoes in public buildings and churches in Connecticut and New York. His paintings have been displayed in Washington D.C., New Jersey, and New York.

Mr. Latella came to America in 1966 and lives in Darien, Connecticut.

ANNE PAOLUCCI

An internationally-acclaimed scholar in multicomparative studies, Italian literature, Shakespeare, dramatic theory, and modern/contemporary theater — especially Luigi Pirandello and Edward Albee — Anne Paolucci is also an award-winning playwright, poet, and fiction writer. Born in Rome, Italy, she attended public schools there and in New York City and later graduated from Barnard College with a degree in English. She continued her studies at Columbia University, where she received her Master's degree in Italian literature (under the mentorship of Giuseppe Prezzolini and Dino Bigongiari), and her Ph.D. (with Maurice Valency as her mentor) on Dante and Spenser in the Department of English & Comparative Literature, where she passed her Oral Examination with "Distinction" and was awarded the first Woodbridge Honorary Fellowship.

A year after her marriage to Henry Paolucci, she and her

husband both won Fulbright Scholarships as students from Columbia to the University of Rome. She later returned to Italy as Fulbright Lecturer in American Drama and taught in that capacity at the University of Naples for two years.

A member of the English Department of The City College of CUNY for a number of years, Dr. Paolucci moved to St. John's University in 1969 as University Research Professor (the first appointment of its kind). She later served as Chairperson of the English Department and Director of their Doctor of Arts Degree Program in English.

Her major writings include *Hegel on Tragedy* (a collection of writings from the entire Hegelian *opus*), prepared with her husband Henry Paolucci; a translation of Machiavelli's *Mandragola* (currently in 38th printing); and what has become a classic in the field, as one of the earliest and most provocative studies on the subject: *From Tension to Tonic: The Plays of Edward Albee.* She is also the author of *Luigi Pirandello: The Recovery of the Modem Stage for Dramatic Art.* Her creative writing includes four books of poetry, a novella, and three collections of short stories, the most recent, *Do Me A Favor (and Other Stories).*

Her continuing activity as founder and president of Council on National Literatures and series editor of its two annual publications (*Review of National Literatures* and *CNL/World Report*), has won her international recognition as a pioneer in the area of multicomparative literary studies. Since the launching of CNL in 1970, she has produced over fifty separate volumes dealing with critical assessments of literatures not in the traditional mainstream.

Dr. Paolucci has lectured at major universities in Italy, Canada, Australia, and the United States; the Shakespeare Institute of Stratford England, and the Chinese University of Hong Kong, as well as major university and cultural centers in Yugoslavia. Her many awards include an honorary degree from Lehman College (CUNY); the Vice-Presidency of the Dante Society of America; the "Golden Lion" Award of Order Sons of

Italy; the Republic of Italy's "Cavaliere Order of Merit" in 1989, and three years later the title of "Commendatore"; the first national Elena Cornaro Award of OSIA; and in 1986, appointment by President Reagan to the National Council on the Humanities, where she continued in that capacity under Presidents Bush and Clinton. Her many cultural and educational projects during the Columbus "countdown" won her Canada's first gold medal for the Columbus quincentenary.

In 1996, she was appointed by New York State Governor George Pataki to a 7-year term as a member of the Board of Trustees of City University of New York, and in 1997 the Governor appointed her the first Chairwoman of that Board.

Married for almost fifty years to Dr. Henry Paolucci, an historian and foreign policy expert, she worked closely with her husband on many academic and cultural projects. In 1999, after her husband's death, she restructured and redirected the activities of Council on National Literatures and set up the CNL/ANNE AND HENRY PAOLUCCI INTERNATIONAL CONFERENCE CENTER in Queens, New York. In March 2000 the Center was officially launched with a multifaceted all-day Conference followed by an Awards Dinner, where college and high school teachers who had enlarged the scope of literary courses and programs, were singled out for prizes.

Printed in Spain by **Editorial MIC** • Campanillas No. 26, 24008
León